MINA ALEXIS

How To Make Money on Model Mayhem

Copyright © 2019 by Mina Alexis

Mina Alexis All rights reserved. No part of this publication may be reproduced, distributed, or transmitted in any form or by any means, including emailing, photocopying, recording, or other electronic or mechanical methods, without the prior written permission of the publisher, except in the case of brief quotations embodied in critical reviews and certain other noncommercial uses permitted by copyright law. Although the author and publisher have made every effort to ensure that the information in this book was correct at press time, the author and publisher do not assume and hereby disclaim any liability to any party for any loss, damage, or disruption caused by errors or omissions, whether such errors or omissions result from negligence, accident, or any other cause. Not affiliated with, approved of or endorsed by Model Mayhem

First edition

This book was professionally typeset on Reedsy. Find out more at reedsy.com

Contents

Introduction: My Story	iv
The Secret To Surviving The Mayhem	vi
How To Read This Book	vii
DAY 1: Get To Know Model Mayhem	1
DAY 2: Create A Name For Yourself	3
DAY 3: Creating Your About Statement	5
DAY 4: Submit Photos To Model Mayhem	7
DAY 5: Building a Professional Portfolio	10
DAY 6: The Importance of an Outstanding Profile Pic	13
DAY 7: Create A Welcome Video	15
DAY 8: The Power of Communication	17
DAY 9: Creating Rates and Invoices	19
DAY 10: Know the Difference Between Scams and Legit Work!!	21
DAY 11: How to Communicate and Book Work with Potential...	23
DAY 12: Getting Ready For Your First Paid Shoot!	26
DAY 13: Giving Photographers Credit/ Post Shoot Ettiquette	28
DAY 14: Availability Notices and Responding to Castings	30
DAY 15: Shoutouts/ Announcements/ Contests/ Vip Membership	32
BONUS BEAUTY TIPS	34
CONGRATULATIONS!	36
About the Author	37

Introduction: My Story

Why is it that in this amazing day and age we live in, so many people still believe that they cannot prosper by following their heart and dreams?

I never wanted to admit that I was a believer of this, until one day while I was working retail, I just simply had enough! I decided to quit my comfortable 9 to 5 job and the next week after that I got a message from a photographer on Model Mayhem offering me paid work to model fitness clothing. It had to be one of the most exciting and happiest moments of my life to get compensated for something that I actually love doing. Now I am currently making triple of what I make in something that I actually enjoy. If you are reading this book, you are in the same position that I was in. Wanting to live a happy and fruitful life while being paid by something that you love, specifically modeling! I created a MM account in 2013, not knowing the potential and income it can bring.

Now that I am aware, I want to share how YOU can also bring in extra money by booking local work through Model Mayhem alone, in just a matter of 2 WEEKS! :)

If you follow the day to day steps and exercises and commit to giving it your all, I guarantee you will see results fairly quickly.

One thing that is a misconception in the modeling industry is that only certain people can model. But honestly, ANYONE CAN!! EVEN YOU! Do not let anyone tell you otherwise. Thank you so much and I wish you success on your new and glamorous adventures! ~ Mina~

The Secret To Surviving The Mayhem

If you have already created an account on Model Mayhem and have not been getting the results you want, it is not because you are not a great model, and people just don't want to work with you.

I have heard so many excuses as to why Model Mayhem just does NOT work for them. "Too unprofessional, too many scams, no one wants to pay." But frankly the two ways to obtain success on this site alone is CONSISTENCY and BELIEF! Putting in at least 10 minutes a day on the site from just networking and adding new friends can make a huge difference. No matter what, you CANNOT give up when you are not seeing results.

I say this because while you are completing this program and when you are finished, you may have months that are slow, or people who are just mean and blatantly insult you. In those hard in slow times, those are the times where you have to push and work harder. Claim that amount of income you want to make that is rightfully yours! You may have close friends and family discourage you. But, I am the one to say that if you stay consistent at this and believe in yourself, you are bound to see amazing results. You can do it, You are doing it. Believe in yourself and NEVER give up.

How To Read This Book

This book is set up for you to get maximum results in 15 days, with only using about an hour a day of your time.

20 Min - READING - 20 Min - TO DO - 20 Min - EXERCISE

Of course, you can take as long as you like, this is just the minimum amount of time I recommend you take to see the results you want. Model Mayhem is all about how many valuable people you are able to connect with. So the more time and effort, the greater results.

DAY 1: Get To Know Model Mayhem

Reading

When first getting on the Model Mayhem website there are tons of things that capture your attention. The pretty model at the top, the login, the contests tabs, Pics of the Day, ect.! You can already see without even logging in or signing up that there is alot of stuff going on.

To Do: Explore Model Mayhem

Take time to look around the site. Have a pen and paper (or your phone does not matter) and write down between 5 to 10 of the MM profile numbers of the portfolios that you like. Take notes of what content they have in their portfolios. These accpunt will be your inspirational guide. Also pay close attention to the work that you are attracted to. Is it Artistic Nudes, Fashion, Lingerie, Body Paint, Fetish? Do you see yourself doing this kind of modeling? This will be your guide to what type of freelance model you would like to be.

Nudes are a really good way to make a lot of money fairly quickly. Whether it is artistic, implied, full nudes or bodypaint, you are still nude and can charge more. Just make sure it fits your preference!

Exercise

Create your Model Mayhem account! Do not worry about uploading a photo or information just yet. Whatever name you choose for your profile will be more discussed in Day 2, so no need to stress about it! Just put anything for now to have the account open. If you already have a model mayhem account open, great! Just follow the instructions in the next paragraph.

Write down your goals and how much money you want to earn in the next two weeks. You will more than likely see results beforehand, but give yourself time to adjust and explore your new career path. Also keep in mind that the more money you'd like to make, the more work and effort you must put in!

DAY 2: Create A Name For Yourself

Reading

Believe it or not, what you call yourself as a model really helps you to book good and legit work. Along with your profile picture, your name is the first thing that people on Model Mayhem will remember you by and also the very first impression you will make on any new and potential clients.... So let's make it count!

To Do

Write down five to ten names that you would be interested in calling yourself as a model. Even if it is the name that you were born with. (Though some models prefer to use their birth given name, I'd recommend using a different name to separate your business from your personal life.)

Exercise

After writing down at least 5 names ask a few people you trust which name they like the best. Honestly, any name can work, but you want to choose a name that photographers can remember and also take you seriously. (Though you can't expect to call yourself BooBoo Keys and get serious bookings!)

If you created an account in Day 1 and already chose a name for yourself and you love it, that is fine! Luckily, if you do decided to change your name, Model Mayhem allows you to do so in the settings tab.

DAY 3: Creating Your About Statement

Reading

One of the most important parts of booking work is having a great and thorough about statement. Even if you have a spectacular portfolio, if your about statement is vague or doesn't give too much detail about who you are, photographers will be skeptical with working with you. You want your about statement to do the work for you. A good about statement aims to answer all of your potential clients questions. I have placed an example of some of my about statement on MM. If you were a photographer, wouldn't you feel comfortable booking me as a model? The more detail you add, the better!

To Do

Look at the about statement from models profile pages as if you were a photographer who is considering booking them. Take notes of the about sections that catch your eye, and the ones that do not.

Exercise

Follow the format for writing your about statement on my model mayhem profile page. My Model Mayhem Profile Number is 2992453. You can copy and paste the about statement from my model mayhem account and use it as a guide. Tell a story about yourself. You want to be as open and receptive as possible and answer as many questions for your clients that you can. While filling out your section start with stating Depends on Assignments under the "Compensation" section. You want to start with this until you get more consistent bookings. I also recommend not adding your rates in the about section, as we will discuss in more detail in a later day. You can get a lot of work by negotiation and talking to clients with private messaging.

DAY 4: Submit Photos To Model Mayhem

Reading

When starting the submitting process with MM, you will need to submit 4 photos for approval. If you already have a profile that is approved on MM, then you will need to make sure you have great quality photos that not only enhances your brand, but also showcases the kind of work that you are trying to recieve. Photos must look professional! Luckily, there are ways to get professional photos on MM without spending little to no money. I will name 3 methods that have worked for me.
1. Option: Take photos with a camera phone or camera and get them professionally retouched. An affordable option would be fiverr.com
2. Option: Ask a photographer for a TFP (time for print) Shoot
3. Option: Pay a photographer for professional photos.

If your profile is not approved yet, you do not have access to communicate with other members. If this is the case, depending on your budget I highly reccomend option 3. If you do not have

at least $300 to spend on a good photographer, Option 1 is the way to go. You can take photos with your phone or camera if you have one, and get them retouched for as little as five dollars on fiverr.com. If your profile is already approved on Model Mayhem, I recommend option 2 and 3. Just make sure that if you are doing option 2 that the photographer enhances your brand and portfolio. It is meant to benefit you and to get you more work.

To Do

After looking at a few profiles and seeing what type of modeling inspires and catches your interest, it is time to create your portfolio. Choose an example of a nice headshot, full body, ¾ and side shot of the styles of modeling you would like to pursue. You can search examples on either MM, online, social media, magazines, ect. Anything that inspires you, take note!

Exercise

For Beginners: Woohoo! Time to do your first photoshoot! Ask a trusty friend or family member to take photos for you, using a camera phone or camera, with the photos you found as an example in your To Do exercise. The photos do not have to be perfect, just as clear as possible. Have fun and be the creative person that you are while shooting! Next, open up a fiverr account on Fiverr.com and find someone to retouch your photos for you. For four photos, it should not be more than $20.

DAY 4: SUBMIT PHOTOS TO MODEL MAYHEM

I recommend using someone who has nice retouched photos in their profile and has positive ratings. Once you get your photos back submit them to model mayhem. It will take a few days, but they should get approved and you will be on your way to professional work! *Of course if you do not want to go this route with getting your photos, you can always pay to get professional photos done. If you are lucky, then you may even be able to get someone to do TFP for you. Just make sure that whatever you choose, that you feel safe and get amazing pics out of deal!*

For Advanced: If you already have a portfolio on Model Mayhem, your best option is to take photos that will enhance your brand. I reccomend doing TFP with a high quality photographer, or just paying to get professional photos done. **The key is to have high quality content that captures the attention of the clients that you are trying to attract. For example, a lingerie model should be taking high quality photos of her in lingerie, in order to attract clients who want that particular look. If she has photos of her in clothing, it will not hinder her from getting potential clients for the work she is looking for, but it will slow down the process.**

If you are having trouble getting great photos from your camera or phone, not doing well with finding someone to do tfp, and dont have alot of money to pay a professional, it is ok! You can always pay or offer to do tfp with a college student pursuing photography at a local college in your area. Since they are still learning their craft, they will charge little to no money!

DAY 5: Building a Professional Portfolio

Reading

Congratulations! You now have four photos successfully in your port and you are an official model on Model Mayhem! That is a lot to accomplish in such a short period of time. So now it is time to confirm the potential of booking as much work as possible. If you want to skip this day with your 4 photos, or if you are already advanced and have more than enough photos in your port, you can go to Day 6! Though it is still possible to book work with only 4 photos, we want to have at least eight eye catching photos before we start looking for potential clients. The more "busy" you seem, the less "BS" you will get when trying to get paid. If you are more advanced and you are looking to rebrand yourself and build your port, it also does not hurt to get more pictues to use in your port. With that being said, it is best to grow your port in the most affordable and efficient way: TFP. Though your port will grow as you start working and networking with more photographers, it is best to try to work with photographers whose work you like and has your preference of what type of modeling you want to pursue. For example, a model looking to receive work

in fashion photography should seek out photographers who predominantly have fashion photography in their portfolio. It is time to start some basic networking and get some TFP photos for your portfolio. TFP meaning Time For Print. Instead of getting paid for your work you are trading your time in for photos. Just like discussed in Day 4.

You Can get some great photos through TFP, I have gotten alot of great photos taken through TFP assignments and they definitely helped to add range and to enhance my portfolio. (Not to mention book more work!)

To Do

Look for 10 local photographers in your area whose work you admire for TFP shots and add them as friends. Comment on at least two of your favorite photos in their portfolio and message them stating that you would like to work with them on a TFP shoot. With already having at least 4 amazing pictures in your profile, I guarantee that most if not all will be willing to shoot with you!

Exercise

Choose about 3 photographers to do TFP with. You don't want to choose any more than three photographers to do TFP shoots with while starting out. Make sure you shoot something

different with each photographer to provide variety in your portfolio.

You may have some photographers that are not willing to do TFP, that is ok! You can defelect this by looking at "Details" on their profile. If it says "paid assignments only," do not expect to get a TFP shoot from them. Simply just go to anothe photorapher, and eventually you will find one that has great work and says yes!

DAY 6: The Importance of an Outstanding Profile Pic

Reading

When someone is first introduced to you on mm, the number one thing they see is your picture, then your name. It is really important to have a great picture that stands out and grasps the attention of others. It will help you to attract more work and attention without doing too much to get it.

A good profile pic on model mayhem is one that has defined colors, meets mm guidelines of not showing too much nudity, and in my opinion faces vertical, because vertical photos seem to appear larger on the site!

To Do

Look on the main page of Model Mayhem. Which photo catches your attention the most, and why?

Exercise

Look at the photos in your port. Choose the one you feel best stands out the most. If you need help, ask a trusting friend or family member. Also do not be afraid to test out photos and see how they do as your profile pic. I have had many photos that were not my favorite, but did do exceptionally well as my default pic.

DAY 7: Create A Welcome Video

Reading

A special trick that I have learned that really helps to seal the deal with new clients is not only a good about statement, but a also a welcome video! Not many models do this, but just letting the photographer see your beautiful personality and self shine in a video before a shoot makes a huge difference and can super seal the deal! This is a really good trick if you are more seasoned on model mayhem and looking to give your profile a little push. Of course you do not need a welcome video, but from my personal experience, it has helped me alot by allowing me to charge higher rates in the long run. Clients are able to meet me before meeting me (if that makes sense) and feel more comfortable with messaging me since they have seen my personality.

To Do

Take a look at some of the profiles on MM, Do you see anyone who offers a welcome video? How do you think adding a welcome video will help you get more bookings in the long run?

Exercise

If you think this will be a great step to get more bookings for you, go ahead and create your welcome video. State your name, what you like and how you would love to work with photographers of all ranges. Also discuss what types of modeling you like shooting. The video doesn't have to be perfect and can be from 1 to 3 minutes long. It just has to give your clients a feel of who you are and what to book you for. Go ahead and try it and see how it works for you!

DAY 8: The Power of Communication

Reading

The number one thing that models generally miss in getting work on MM is the basic step of simply communicating with potential clients. And when I say communicate, I do not mean just advertising yourself or spamming your services on other profiles, but simply treating people online like they are human beings. By simply saying hello, commenting on photos and treating everyone you come in contact with the respect they deserve online, you will be sure to get alot of business!

A Golden rule to remember is to "treat everyone you encounter as if they are the most important person in the world. 9 times out of 10, they will do the same"- Earl Nightingale

To Do

Look at other profiles on mm and the different tags (also known as comments) on their pages. How many of these tags would you consider spam?

Exercise

Begin to add more friends on your Model Mayhem Profile. I recommend adding at least 5 local profiles in your area a day. Comment on at least 1 to 3 photos in their portfolio and write a friendly tag to everyone you encounter. Keep every comment and tag unique and original. See how much positive responses and business you get back in return!

DAY 9: Creating Rates and Invoices

Reading

The one thing that can easily make or break a sale is the amount you charge during a shoot. There are many ways to go about this You can charge hourly, or have a set price. Depending on what type of modeling you want to pursue will determine what route you want to take. It is also good that when a price is set, you email or give your client in person an invoice of what they are shooting and for how many hours. It makes you look highly professional, helps you keep track of the amount of work you get each month, and also helps your client feel secure!

To Do

Do some research on creating invoices. You will see that they are fairly simple to make and highly important for any freelance business. I reccomend taking a look at google spreadsheet, or even paypal.

Exercise

Start off with these basic beginner rates, once you become booked with work you will be able to charge more. If you are just pursuing a career in fashion and/or lingerie and feel uncomfortable with nudes, just start with $45 an hour minimum 2 hours. That is still a $90 booking! If you are just starting out, I do not reccomend taking any fetish, erotic, or bdsm work. That kind of work pays very well, but can be dangerous if you are just starting out and you do not know the photographer well. Unless the photographer is offering a really great deal for your portfolio or career (legit work), do NOT lower your price!

<div align="center">

Basic Beginner Rates:
Clothes/Swimwear: $45
Lingerie/Implied Nudes: $65
Nudes: $85

</div>

Also take some time to create your first invoice! It is not a necessity, but it will make the process of booking shoots and keeping track of your income a lot more easier!

DAY 10: Know the Difference Between Scams and Legit Work!!

Reading

What makes Model Mayhem leery and untrustworthy to some people is the amount of scams that people try to pull on the site. Not only that, the amount of bad people that can potentially harm you if you are not careful. It is HIGHLY IMPORTANT to know all the red flags of scam or danger when booking work as a freelance model. I reccomend to not book any work until you learn how these scams work. With my neglegance, I myself have gotten into alot of bad situations and headache because I did not take the simple step of educationg myself on scams. Usually, if it seems too good be true, it is not! The issuse of scams and dangerous people is why being a freelance model and model mayhem get discredited, but if you are smart enough to catch a scam before even responding to it, you will save a lot of time and can continue to focus on real work. As well as get paid $$.

To Do

Read this Forum Post: The New Model's Guide to the Industry and Scams on Model Mayhem and Inform yourself on what to look out for while booking work.
 Click the link to Learn about Scams:
 https://www.modelmayhem.com/forums/post/575330

Exercise

Go through your messages and delete any scammers. Make sure to follow the forum and if you want, you can also report them.

DAY 11: How to Communicate and Book Work with Potential Clients

Reading

You have networked your pants off and are finally getting some buzz, and now people are asking to work with you! How cool is that!? An effective way to communicate with potential clients is to talk conversationally. Do not just throw your rates out there if they do not ask. Sometimes potential clients like to get a feel of who you are by just saying hello, or commenting on your portfolio before they even mention wanting to work with you.

To Do

Take a look at the conversation I have attached below from a client I have worked with. Can you see how effective it is to speak to your client as a human being?

PHOTOGRAPHER: "Hi Mina, I would love to do a shoot with you. I'm interested in headshoots, portraits, lifestyle and bikini shots for a first shoot. What are your rates? Have a great day," Photographer

ME: "Hi! Excellent! I have listed my rates below. Hopefully we can schedule something for next week if you are available! Also, can you please let me know what date, time, and location you would like to shoot? Thank you so much and I believe we can create beautiful work! Rates: (Minimum 2 hours) Fashion/Swim: $55 Lingerie/Implied: $75 Nudes: $95 "

PHOTOGRAPHER: "How about next Saturday 2pm-4pm at Brennan Park? For hair and makeup, I like a "natural" look, though however you are wearing your hair is fine, natural, braids or straightened. For outfits, shorts, summer dress and one or two bikinis. I am open to suggestions, if you like an outfit, it will come across well."

DAY 11: HOW TO COMMUNICATE AND BOOK WORK WITH POTENTIAL...

ME: "I wear the natural look really well so I think you will definitely be pleased. And I have a great variety of shorts, summer dresses and bikinis I think you would really like also. I look forward to shooting with you this weekend. I will be sending an invoice to your email!"

PHOTOGRAPHER: "Great! Got it!"

ME: "Perfect! See you then!"

Exercise

Follow this format when speaking to Potential clients. Always ask the questions who what where when and how much you will be compensated while booking a shoot. Make sure that the client answers all of your questions. If you feel uncomfortable with going to work with a new client, some clients allow you to bring an escort and some don't. For the ones that don't, do not automatically assume that they are scams, they could just be shy and feel pressured when someone is around. So just simply ask them why you cannot bring an escort and judge them by their answer and your intuition.

You can also ask to facetime, video chat, or meet prior to shooting, or you can even suggest a safe location to shoot. The key is to feel safe AT ALL TIMES!

DAY 12: Getting Ready For Your First Paid Shoot!

Reading

Yes!! How exciting is it that you have booked your first gig?! Now you must be ready and prepared to know what to expect at your first paid shoot. It is very important that you have communicated with the photographer about the shoot amount being compensated, the time, location, and all of the who, what when where, how's have been answered.

To Do

It is important that you are properly prepared for your photoshoot! I have a list of basic things that you will need for each and every shoot you will do.
- **Basic Makeup kit: Foundation, Concealer, lipstick, eyeliner, and lashes are fine.**
- **Exercise and Eating: You want your body to look its best; follow a workout routine that works best for you! Eat**

foods that will not leave you feeling bloated or sick.
- **Communication:** Always Communicate with your client. Reply with enthusiasm and let them know that you will be there 10 minutes early, and if need be, 10 mins late!
- **Wardrobe:** Even if they say you don't have to bring clothes, you should always bring some. You can't be too prepared for anything.
- **Skin Care:** You MUST protect and care for your skin, teeth and nails. It makes all the difference in photos.

Exercise

Get your mini modeling kit ready and start a workout routine and better eating habits if you do not have them already. The more prepared and good you look, the more money you will be making!

DAY 13: Giving Photographers Credit/ Post Shoot Ettiquette

Reading

So you just finished a fantastic shoot with a new client. Congratulations!! Now you must show them how much you appreciate them for giving you their time and money. A great way to do this is to add them as photographers to work with on your about page. Take a look at this as an example:

Post Shoot Etiquette: After a shoot, Always thank your client for their time. You can do this with a message, a tag on their page, an ecard, I recommend doing all three! A great message to write would be something like this:

"It was truly a pleasure working with you, looking forward to working with you again, hopefully sometime in the next month or two!"

- Model's Name

This way you thank them and possibly have booked another shoot with them in the near future. For me it works 90% of the time. Also, don't be afraid to check back and ask them if they would like to shoot again or when is their next availability. A model who can book shoots a month or two ahead is truly a model

DAY 13: GIVING PHOTOGRAPHERS CREDIT/ POST SHOOT ETTIQUETTE

that has is going on! And you never know, they may book another shoot as soon as the next week!

To Do

Give Credit to each client that you have worked with on your profile. This builds a great trust with your loyal clientele and also makes them super willing to work with you again. If you use a photo from a photographer in your portfolio, give them credit underneath the photo as well.

Exercise

Thank everyone that you have worked with by using the example shown above in the reading section. How much positive feedback have you gotten back in return? How many clients have left you positive credits on your profile?

DAY 14: Availability Notices and Responding to Castings

Reading

You have made it this far and I am so proud of you! Give yourself a round of applause and go treat yourself to something special! So far you have created a professional name for yourself, learned how to network, and also have a new way to make extra money in your pocket. Now it is time to kick it up a notch with a few easy tricks that I will explain in these last two days. Today you will learn how to create availability notices and respond to castings. Making notices and responding to castings is not only a great way to make extra money, it is also a wonderful way to network as well, especially as a local model. You might already be familiar of this if you worked with a photographer for a TFP shoot.

Here are all the types of casting and availability notices broken down.
- Local Castings: Local castings help you to find work close in your area
- Local Availability Notices: Help others find you so they will be able to work with you in the area.

DAY 14: AVAILABILITY NOTICES AND RESPONDING TO CASTINGS

- Travel Notices: Allows potential clients in the area of travel to find you and to have the potential of booking you for work.

- Always require a direct deposit of at least $50 if you decide to travel to different cities
-A good price for travel castings should be a set price of $100 an hour, minimum 2 hours. I do not reccomend travelling out of state if you are just beginning.

For local availability notices I like to give a discounted rate to bring in more new and consistent clients. Usually ranging from 100 to 175 for a two hour shoot for fashion, swim and lingerie. This is a great way to bring in extra clientele and to also put extra money in your pocket.

To Do

If you click the castings at the top of the site, you will see three sections that say local, travel, and casting. You want to make sure you are active in all three.

Exercise

Create your first local availability casting. See who responds and is willing to work with you at your discounted rate.

DAY 15: Shoutouts/ Announcements/ Contests/ Vip Membership

Reading

If you are having trouble booking work or just feel like your profile needs a little boost to be seen, I highly recommend upgrading your profile to the VIP membership. I have had it for myself and it really helps your profile stand out more. It also gives potential clients the feeling that you are a professional model. You are also able to post frequent shoutouts, castings, and announcements as an VIP member. Not to mention the fun perks you can add on your about page! If you are not ready to upgrade your account, you can still build more exposure by doing post announcements on the main page, shout outs on the shoutout tab, writing a bulletin post, and entering the latest model mayhem contest. It is also very beneficial to respond to others who are involved as well. It brings more traffic to your profile which can lead to more potential clients!

Shout Outs are my favorite way to meet and talk to new people on Model Mayhem. Try it yourself!

DAY 15: SHOUTOUTS/ ANNOUNCEMENTS/ CONTESTS/ VIP MEMBERSHIP

To Do

Go to the VIP membership information on model mayhem account and read all of the perks it has to offer.

Exercise

Create a shoutout, post announcement, and bulletin post. Also enter a contest. If you are able to post consistently and respond to other post as well at least once a day, you will create a huge network very quickly.

BONUS BEAUTY TIPS

HOORAY! You have completed the 15 day process You are on a roll. As a reward, here is a bonus section on beauty tips that are easy and on the go that are all under $30!

1. **Banana Peel** - Great for your face! Gives you a glow in 15 minutes and shrinks acne in a few days. Jus let it sit for 15 minutes, then rinse with cool water.

2. **Chemical Peel** - great for clearly dead skin cells and keeping skin flawless. I recommend doing your research and using the glyceric acid peel 30%.

3. **Sugar Coconut Oil Scrub** - My favorite face and Body Scrubs! Mix a cup of coconut oil. Scrub all over your face and body and see the glow and refreshing feel it gives your skin.

4. **Coconut Oil Teeth Pulling** - Put a spoonful of coconut oil in your mouth and swish it around for 20 minutes. See the results it does for whitening your teeth.

5. **Whitening strips -** You can buy these at a local drug store. One of the cheapest / and most efficient ways to get whiter

instantly!

6. **Clear Nail Polish** - Putting clear nail polish on your toes and fingernails really does well in shoots. Brings a nice clear glossy shine in photos.

7. **Olive Oil** - Also highly recommended. Brings a settle glow to your skin in photos.

8. **Shea Butter** - Highly recommend, great for your hair and brings a nice glow to your skin

9. **Lemon water Detox** - Great to clean out your system throughout the day. Slice up on lime and lemon and put 2 to 3 slices of each in your water. Drink it throughout the day and before and after you go to bed.

10. **Wigs** - A great way to switch up your look and be fabulous while on the go. I love using wigs during shoots because I can switch up my look while saving a lot of time.

11. **Face Massager** - A wonderful cheap way to slim out your face! I love to use my face massager when I wake up and when I go to bed for about 10 minutes. Here is the link to buy one

THANK YOU!

CONGRATULATIONS!

CONGRATULATIONS! You have read everything you need to be the best of the best on Model Mayhem. You have learned how to build a professional profile for yourself, network with local and non local clients, how to communicate with others on the site, and most importantly a way to get paid on something you love! As long as you stay consistent and have the mindset of success, you will continue to be amazing at not just as a local freelance model but with anything you do. Continue to aim for the Stars and be the hottest freelance super model you can be!

Make sure you add me as a friend on Model Mayhem! I truly look forward to hearing all of your results, and if you have any questions, feel free to talk to me on model mayhem!

About the Author

I enjoy helping others and giving advice. I look forward to making more young women's lives prosper and giving knowledge where I can! ~ Mina Alexis ~

You can connect with me on:
🌐 http://www.modelmayhem.com/2992453

www.ingramcontent.com/pod-product-compliance
Lightning Source LLC
Chambersburg PA
CBHW030737180526
45157CB00008BA/3202